THE ART OF THE
SURREALISTS

Edmund Swinglehurst

A Compilation of Works from the
BRIDGEMAN ART LIBRARY

This is a Parragon Book
This edition published in 2003

Parragon, Queen Street House, 4 Queen Street, Bath BA1 1HE, UK

Copyright © Parragon 1995

ISBN 0-75251-116-5

Printed in China

Editor:	Barbara Horn, Alexa Stace, Alison Stace, Tucker Slingsby Ltd and Jennifer Warner
Designer:	Robert Mathias and Helen Mathias
Picture Research:	Kathy Lockley

The publishers would like to thank Joanna Hartley at the Bridgeman Art Library
for her invaluable help.

SURREALISTS

IN THE SENSE THAT Surrealism is an expression of the unconventional thoughts of the subconscious mind it has always existed in art. Hieronymous Bosch, the Dutch painter of fantasies, William Blake, the English visionary painter and poet, and the German Caspar David Friedrich with his strange and mysterious landscapes, all explored the worlds beyond apparent reality.

Surrealism as a declared aim of art first made an appearance in Paris in 1924. André Breton, who was a student of psychiatry, thought that art and life could be regenerated by liberating the subconscious mind. From his studio in Rue Fontaine, where he gathered with his artist and literary friends, he issued the first Surrealist manifesto. This was followed by *La Revolution Surrealiste*, the first Surrealist newspaper. Those who joined the movement, including Max Ernst and André Masson, thought that traditional Western culture had no more to offer the world and that a clean break needed to be made. In order to do this it was necessary to cut the cultural umbilical cord linking the present to the past and to look for new ideas in the world of the subconscious that Freud, Jung and other psychologists were discovering.

They were not the first to want to liberate art from its Greco-Roman cultural chains. The Dadaists, naming themselves after the French colloquialism for rocking horse, had set out a few years earlier to destroy all past art

and create an art without roots. Their enthusiasm for destroying the past was such that they offered visitors to their exhibitions a hatchet with which to express their opinions. Breton had been a Dadaist with Tristan Tzara and Francis Picabia but, realizing that Dada destructiveness would be short-lived without a positive aim, separated from the rest of the Dadaists and launched the idea of Surrealism.

In his manifesto Breton laid down the guiding principles for the new movement: Surrealism would not offer a new and easier means of expression, nor was it to be a metaphysical kind of poetry; it would be a means to the total liberation of the mind and of everything that resembled it

In order to release the subconscious, Breton adopted the process of automatic writing: putting down the first thoughts that came to mind and ignoring the censorship of the conscious ego. Painters adopted similar tactics with automatic drawing; some of them even drew and painted in semi-darkness and created pictures out of ephemeral rubbish.

With a positive aim for their art, the Surrealists quickly supplanted the Dadaists and began to promote their own work. The first Surrealist exhibition in 1925 took place at the Galerie Pierre, Paris, with a great range of contributors, including Giorgio de Chirico, Paul Klee, Jean (Hans) Arp, Ernst, Man Ray, Jean Miró and Pablo Picasso. The diversity of their art showed at once that, unlike the Impressionist movement some half a century earlier, the Surrealists were an eclectic group without a common style of painting and united only in turning to their subconscious for inspiration.

Breton, who was a radical left-wing thinker, had

something else in mind, too, which was that the new art would reach a common stratum of culture common to all human beings and not only to the educated, privileged classes. The new art would express the hidden desires and wishes of all the people with the innocence of childhood and would therefore be easily accessible to everyone. Surrealism was to revolutionize Western culture, enabling people to look at the world afresh. Many Surrealists were, however, products of an élite intellectual culture and their work – such as that of Vasily Kandinsky, Miró and Yves Tanguy -was rather esoteric; nor did the political aspects of Surrealism attract them.

An exception to the abstractions of early Surrealism was the work of Chirico, an Italian, who since 1917, when he had founded Pittura Metafisica with his friend Carlo Carra, had painted pictures that would later be drawn into the Surrealist world. Chirico differed from the other early Surrealists in that he painted realistic scenes with backgrounds of classical architecture and with shop dummy figures that were perfectly recognizable as real objects.

In the 1930s some Surrealists followed his lead and began to paint pictures of recognizable objects, though these were sometimes distorted and placed in unusual situations. The main protagonists of this kind of Surrealism were Paul Delvaux, Salvador Dalí and René Magritte. The visual accessibility of their work, though the public could only guess at its significance, made it possible for Surrealism to reach a wider public through fashion, commercial art and the media and it thus became established as a form of graphic expression worldwide, to some extent bringing Breton's ideas to fruition.

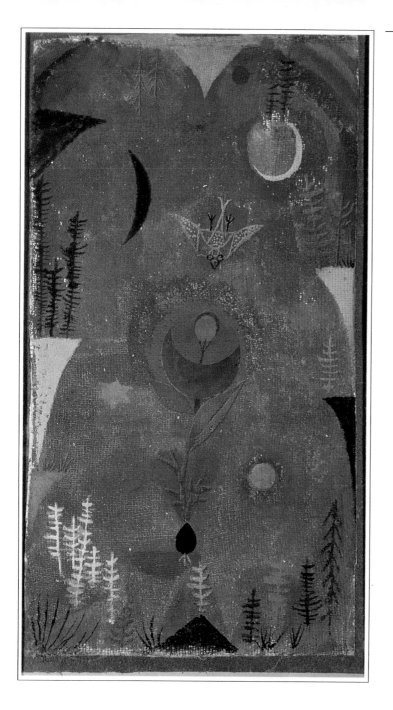

◁ **Blumenmythos** 1918
Paul Klee (1879-1940)
© DACS 1995

Oil on canvas

THE IDIOSYNCRATIC and highly
imaginative work of the Swiss
artist Paul Klee is unique and
does not belong to a
recognizable progression of
artistic ideas. Klee himself
described his method as
'taking a line for a walk', which
is akin to a child's remark
about having a thought and
putting a line around it. Klee's
childlike talent for free fantasy
made him famous by the time
he was 40. Though his work
was intensely subjective and
personal, Klee was not entirely
innocent of the processes of art
and had studied the work of
William Blake, Aubrey
Beardsley, Francesco Goya and
James Ensor before arriving at
his own solutions. His clear
ideas on the subject earned
him a place as a teacher at the
Bauhaus at Weimar in
Germany, the most influential
art centre in Europe.

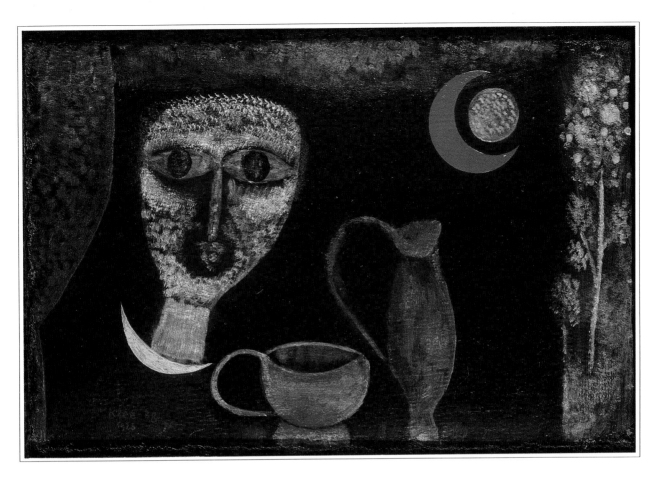

△ **Keramisch Mystisch** c.1914-20 Paul Klee
© DACS 1995

Oil on canvas

KLEE'S TITLES for his pictures are pointers to the inner meaning of his work, as in this one, which links mysticism and ceramics. The dominant yellow face balancing on a new moon echoed in the golden circle in the arms of a red moon seems to suggest the mystical communication between the spirit of human, the creative being, and human, the earthy animal. Pots are a symbol of this dual nature of humankind. This is a rational and literary explanation of the picture. Klee's painting says more than this, however, using a visual language that stimulates subconscious thought through the eye of the observer.

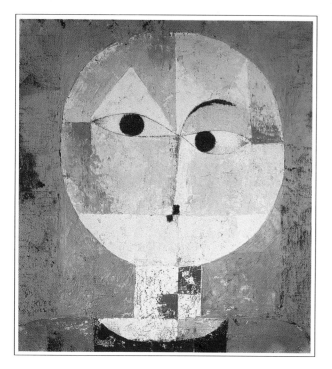

△ **Senecio** 1922
Paul Klee
© DACS 1995

Oil on canvas

KLEE USED HIS DELICATE sense of colour with great skill during the period when his forms were broken up into small shapes or a fine line described an object against a squared background. In this painting the subject and the abstract painting complement each other perfectly, each giving the other a depth of meaning that it would otherwise lack. Klee had a flair for creating reality out of abstraction and vice versa. In his early years he kept the size of his canvases small. After about 1920, he ventured on to larger areas but always kept his compositions simple so that their size would not overwhelm their artistic and human message.

▷ **The Little Tale of a Little Dwarf** c.1920
Paul Klee
© DACS 1995

Oil on canvas

KLEE'S PAINTINGS are often poetic and he sometimes, as in this painting, emphasizes the poetic character of the title. They are also musical in their use of colours and tones. Klee's father was a musician and music teacher and Klee himself played the violin and viola, so he was able to formulate his ideas in musical as well as visual terms. In this painting, with its fine line, subtle tones and fairytale title, there is much of the feeling of those narratives with musical accompaniment that composers produce from time to time. For Klee, music and painting were sister arts, whose languages were analogous, and his work has much in common with that of composers of his time, such as Ravel, Debussy and Stravinsky.

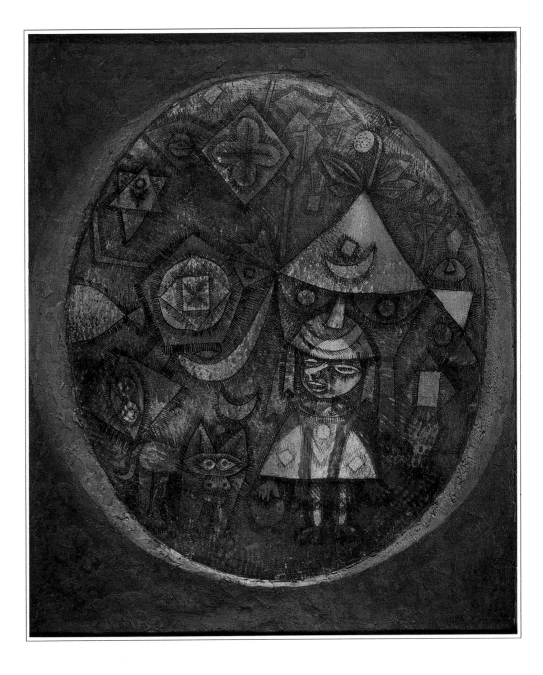

▷ **Parade Amoureuse** 1917
Francis Picabia (1879-1953)
© ADAGP/SPADEM, Paris and DACS, London 1995

Oil on canvas

PARIS-BORN FRANCIS PICABIA
was a highly intellectual and
imaginative man and also
something of a dilettante,
leaping from one idea to
another like a precocious
mountain goat. Like many
artists of his time, he believed
that art, including that of the
Post-Impressionists, was still
feeding on the Greco-Roman
Renaissance culture and
dressing up old concepts in
new clothes. Having flirted
with Cubism, he joined up
with Marcel Duchamp to
launch the idea of Dada.
By the mid-1920s he was
working in the Surrealist
way. His own work was
eclectic, ricocheting from
the figurative to the abstract.
In this painting he evidently
intends a contradiction
between the subject and the
title, and the painting hovers
between abstraction and
surrealism.

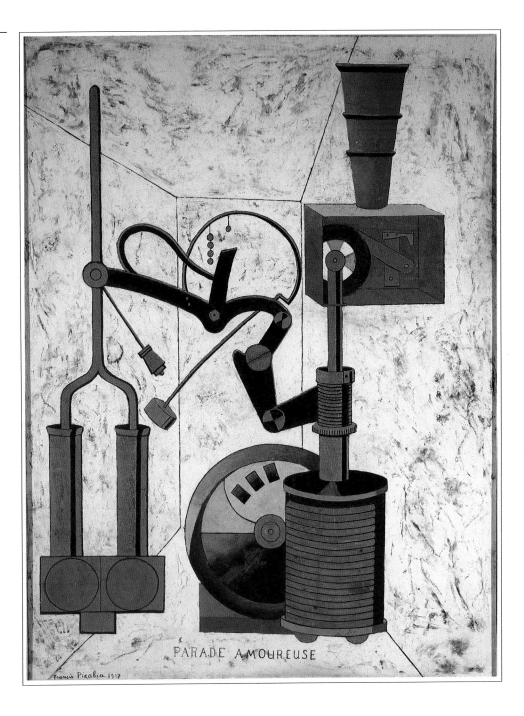

PARADE AMOUREUSE

Francis Picabia 1917

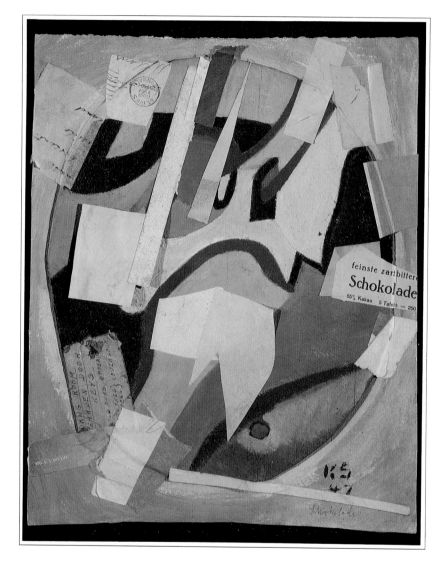

◁ **Mirror** 1920s
Kurt Schwitters (1887-1948)
© DACS 1995

Collage

THOUGH COLLAGES made up of
bits of paper or rubbish were
an anti-art gesture of the
Dadaists, they also carried the
message that art was not only
work presented in a
respectable guise with a
varnished surface and a gold-
leaf frame. Art, said the collage
makers, could be made out of
old newspapers, tickets,
cigarette packs, beer mats and
all the rest of the ephemera of
everyday life. What made it art
was the artistic vision of the
artist and viewer looking at an
arrangement that could well
have come together in an
arbitrary manner, as when
Jean Arp dropped fragments
of paper on to a sheet of
drawing paper or board. In
this collage Schwitters has
added paint in some areas,
suggesting that some conscious
thought has gone into
completing the composition.
The collage has considerable
charm and is reminiscent of
the flat Cubism of a Picasso
still life.

▷ **Chocolat** 1947
Kurt Schwitters
© DACS 1995

Collage

PUTTING TOGETHER COLLAGES or assembling constructions of pieces of wood in a manner that was aesthetically pleasing and also poetic was a special talent of Kurt Schwitters. He studied in Dresden and later came across Dadaism and Surrealism in Paris. Among his first works were collages made up of pieces of wood that he picked up here and there. He also made collages out of any old bits of paper that he came across. One of these collages included an advertisement for the Commerz and Privatbank from which the syllable *merz* stood out in the finished composition. After this, Schwitter's own brand of Dadaism/Surrealism came to be known as *merz*. In 1920 Schwitters, who was an indefatigable collector of ephemera and oddments thrown away by people, began to build a *merzbau* from his collections of rubbish. It was destroyed in 1943 so Schwitters built another in Norway, which was also later destroyed. Finally, escaping to England from Norway during the war, Schwitters began a third *merzbau* in Ambleside in the Lake District. This one, though incomplete, survives in the care of Newcastle University.

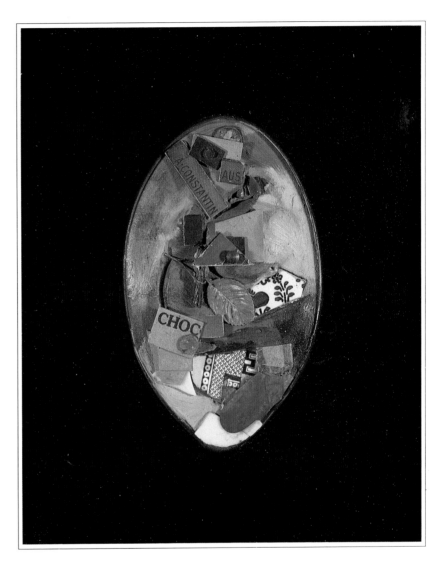

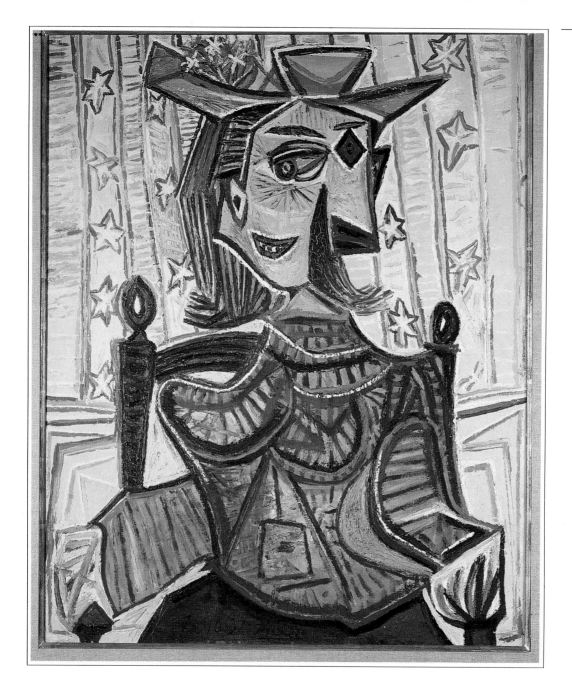

◁ **Portrait of Dora Maar Sitting** c.1938 Pablo Picasso (1881-1973)
© DACS 1995

Oil on canvas

PABLO PICASSO, whose artistic curiosity and vitality took him into every field of art, became interested in Surrealism after his Cubist period. Having taken the rational form of this technique as far as he could, Picasso was looking for a fresh way to express the emotive content of his earlier blue and rose periods, and Surrealism seemed an avenue worth exploring. From about 1923 he began to combine classical memories with a direct response to the subject in a manner derived from his Cubist experiments. The result was a series of distorted figures with great actuality and at the same time a subconscious reality. From this, he developed one of his most effective series of paintings. Dora Maar, his mistress in the 1930s, became the subject of many of these grotesque Surrealist figures.

Chocolate Grinder No.1 1913 Marcel Duchamp (1887-1968)
© ADAGP, Paris and DACS, London 1995

Gouache

▷ *Overleaf page 18*

MARCEL DUCHAMP was one of three painter brothers, his brothers working as Jacques Villon and Raymond Duchamp-Villon. After going through Fauve and Cubist phases, Marcel Duchamp discovered Surrealism and was to have a powerful influence on other artists in the movement. His Cubist picture *Nude Descending a Staircase* (of which there are two versions), had already attracted attention in 1912 and as a Surrealist he continued to produce startling work. Objects such as his *Optical Machine*, a glass panel that required the viewer to stare at it for one hour with one eye closed, brought him some notoriety, as did his 'ready-mades' – anything that comes to hand turned into art. A man of wide interests, Marcel played professional chess and published a book on end games. In this early work Duchamp achieves a *trompe l'oeil* effect with the easel and canvas.

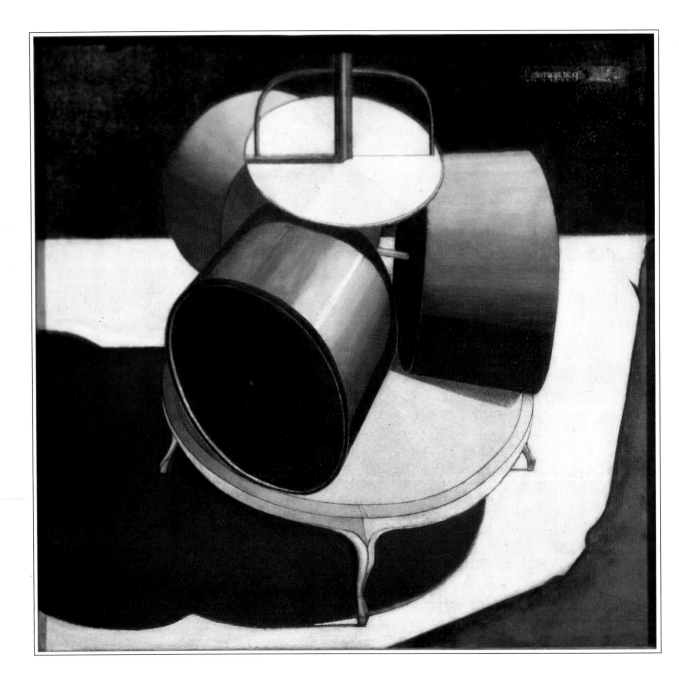

▷ **Composition** c.1920
Jean (Hans) Arp (1887-1966)
© DACS 1995

Collage

JEAN (HANS) ARP was born in
Alsace, a region long in
dispute between France and
Germany. He studied first at
the Ecole des Arts Decoratifs in
Strasbourg and then in Paris.
From 1905-7 he was at Weimar
where he met and was much
stimulated by the work of
Ernst, Kandinsky and Klee. It
was as a result of meeting
Kandinsky that he began to
exhibit in the Blaue Reiter
exhibitions. A natural non-
conformist, Arp found a fellow
rebel in Picabia and joined
him and Duchamp in
founding the Dada movement.
He was at the first meeting of
the Dadaists at the Café
Voltaire in Zurich. From this,
came Abstraction and
Surrealism, both processes
intended as means of
destroying the traditional roots
of Western art. The abstract
seen here was created by Arp's
method of tearing up bits of
paper and letting them fall
arbitrarily on to a piece of
coloured paper.

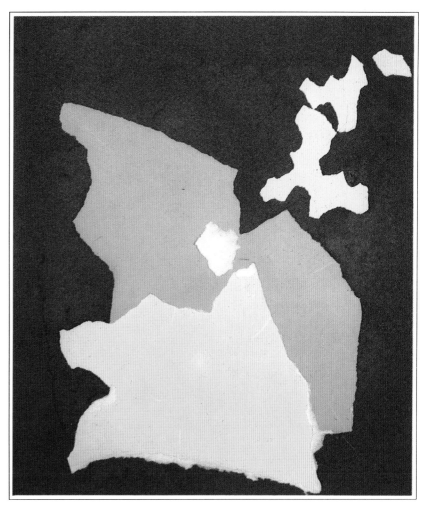

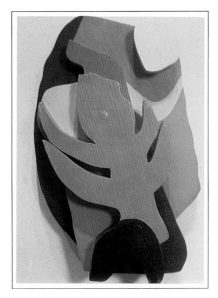

△ **The Forest** 1916
Jean (Hans) Arp
© DACS 1995

Relief sculpture

ARP, WHO BECAME WELL KNOWN for the sexually based forms of his sculpture, made many collages and reliefs constructed of wooden shapes. Most of them were assembled arbitrarily, allowing the subconscious creative instincts of the artist full play in the same way as automatic writing was used by writers. In this relief the forms suggest trees and could be construed as a schematic description of reality, but the fact that the forest is actually odd bits of timber has a significance. The main influence on Arp at this period in his artistic development was Max Ernst with whom he developed a collage technique that they called *Fatagaga – Fabrication de tableaux garantis gasometrique,* a typical Dada gesture against conventional art.

▷ **The Melancholy of Departure** 1916
Giorgio de' Chirico
(1888-1978)
© DACS 1995

Oil on canvas

GIORGIO DE' CHIRICO was a highly intellectual painter who became obsessed with exploring the new artistic concepts of the turn of the century. Born in Greece, he trained in Athens, where he was surrounded by the atmosphere of Greek classical art. He then went to Munich and Italy where he studied Renaissance culture. By 1911 he was in Paris, where he was caught up by the Cubist movement. Called up for military service and wounded during the First World War and while in hospital in Ferrara he met the artist Carlo Carrà. Together they developed a quasi-Surrealistic style of art that they called *Pittura Metafisica.* Chirico began to paint dreamlike paintings evoking the classical past. In this early painting with its tantalizing title, he contrasts the reality of the map with the imaginary construction made up of suggestably useful items.

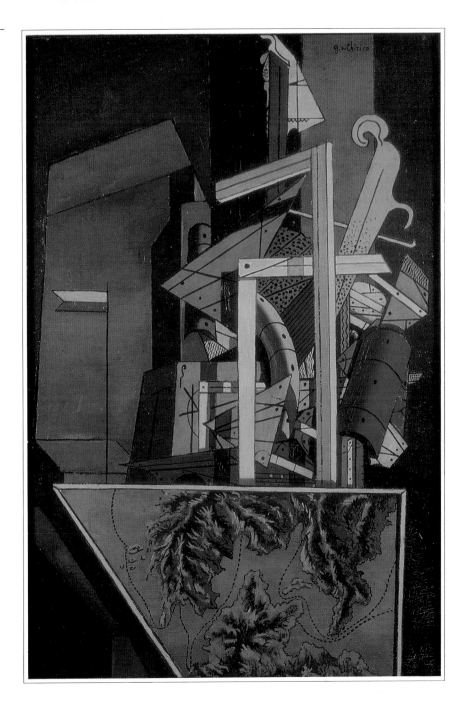

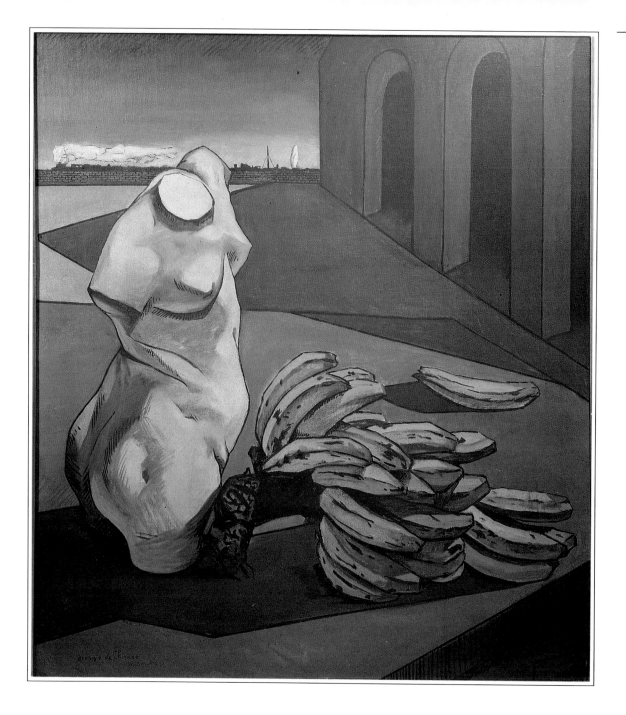

◁ **The Uncertainty of the Poet**
1913
Giorgio de Chirico
© DACS 1995

Oil on canvas

WHEN CHIRICO COMPLETED this work he was living in Paris and had already begun to paint pictures that would later be called Surrealist. He began to use realistic objects in his paintings before this form of Surrealism was developed by Dalí and Magritte. His aim, in accordance with the idea of Pittura Metafisica, was to free art from the mechanical aspects of Cubism, which was then the fashionable art movement, and to restore points of contact with the spectator. This mysterious picture of a female torso and a bunch of bananas, with a railway train and shipping in the distance, serves its purpose in that, visually, it is more accessible than more abstract kinds of painting; but the meaning is not clear, though there is a suggestion of antiquity and travelling and perhaps a hint of the ideas of Sigmund Freud. In 1957 Chirico painted another version of this picture which he called *Piazza d'Italia,* in which he omitted the train and the ship.

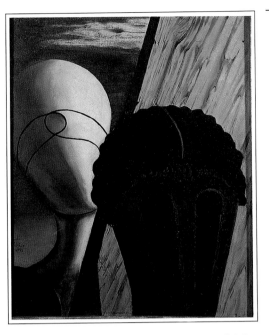

△ **Two Heads** 1915 Giorgio de Chirico © DACS 1995

Oil on canvas

CHIRICO MOVED TO ROME in 1918 and there a change took place in his feelings about his aims in art. Dreamlike urban landscapes and dummy figures no longer served to express what he felt and he began to reconsider his work. By 1925, when he had returned to Paris and to a traditional and classical style of painting, he was accused by his former friends of betraying of their Surrealist cause. Though Chirico had turned his back on what he regarded as his 'unregenerate' period of painting, there is no doubt that the impact of his work then was far greater than his later, more conventional work. In this painting with its egg-shaped and featureless head and red head with porticoed eyes and waved hair, he produced an unusual and stimulating work that suggests inhabitants of a world which is both present and in another time and space. Later in his life Chirico returned to his original painting style while at the same time carrying on his more conventional work.

▷ **Bronze Ballet** 1940
Edward Wadsworth (1889-1949)

Oil on canvas

THIS PAINTING COULD as well be thought of as a still life as an example of Surrealism, for the objects in it lack the unfamiliar confrontation that one expects of a Surrealist painting. However, there is a certain strange atmosphere about it that seems to confirm Magritte's belief that the essential quality of Surrealism is to provoke feelings not necessarily attached to the conventional object. For example, he believed that it should be possible for a leg of ham to be as frightening as a lion. It is in this context that Wadsworth's work fits into the Surrealist frame.

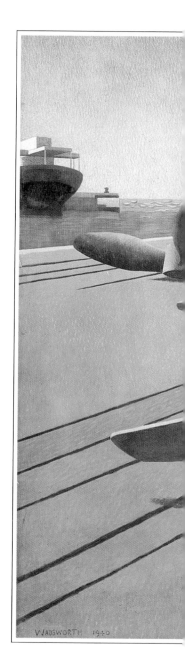

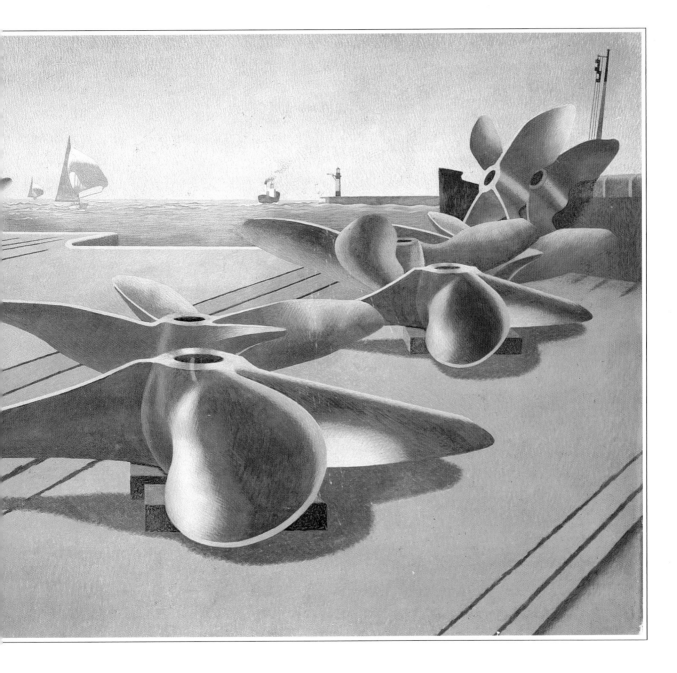

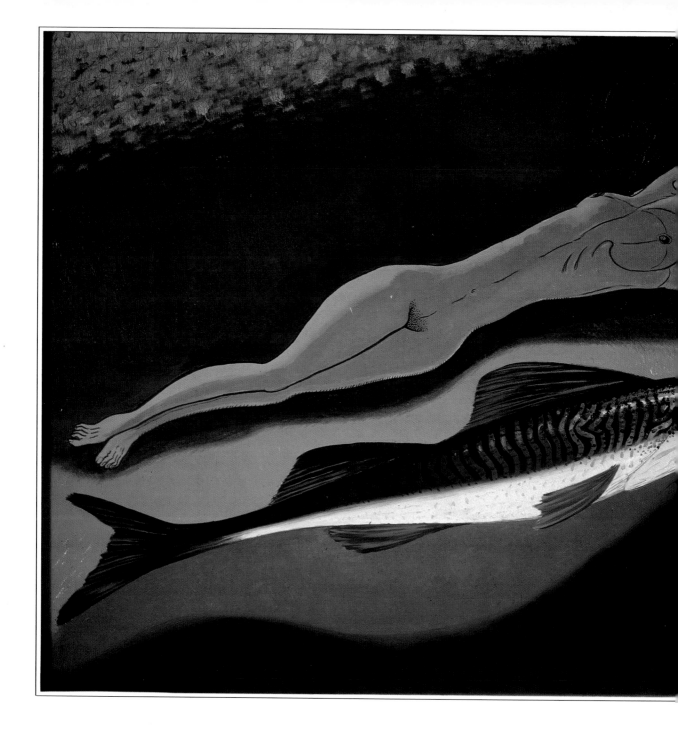

◁ **Pisces** 1938
Man Ray (1890-1976)
© ADAGP/SPADEM, Paris and DACS, London 1995

Oil on canvas

THE RELEVANCE of the mackerel to the nude woman- the painting is sometimes called *Woman with Her Fish* – seems too aware for a truly subconscious painting, but it is a fine example of Dada by an American Surrealist. Man Ray, who trained as an architect, took up painting in 1907. He was first attracted to the new form of art when he saw a Post-Impressionist exhibition at the Armoury, New York, in 1913. He later became friends with Marcel Duchamp in Paris, was attracted to Dada, and participated in the first Surrealist Exhibition. In the late 1920s he turned to photography and film making. When war broke out in Europe in 1939, Man Ray went back to the United States, remaining there until 1954, when he returned to work in Paris and to exhibit his *Shakespeare's Equations*, paintings inspired by mathematical instruments.

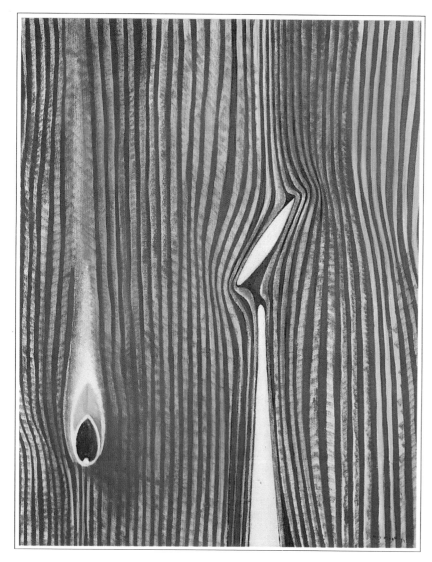

◁ **Blind Swimmer: The Effect of Contact** 1934
Max Ernst (1891-1976)
© SPADEM/ADAGP, Paris and DACS, London 1995
Oil on canvas

MAX ERNST STUDIED philosophy at Bonn University and became a close friend of Arp in 1914, sharing his ideas about the need for a new concept of art divorced from the decaying traditions of the Renaissance. It was natural, therefore, that he should become a Dadaist. With his friend Johannes Baargeld he set up the first exhibition of this anarchical movement in 1919 in Cologne and also began the publication of *Die Schammade,* a short-lived review that campaigned for Dada ideas. In 1922 Ernst moved to Paris and within a couple of years had become involved in the Surrealist movement, devoting himself to work in collages and frottages (rubbings). In this enigmatical work Ernst has used an image that hovers between reality and abstraction.

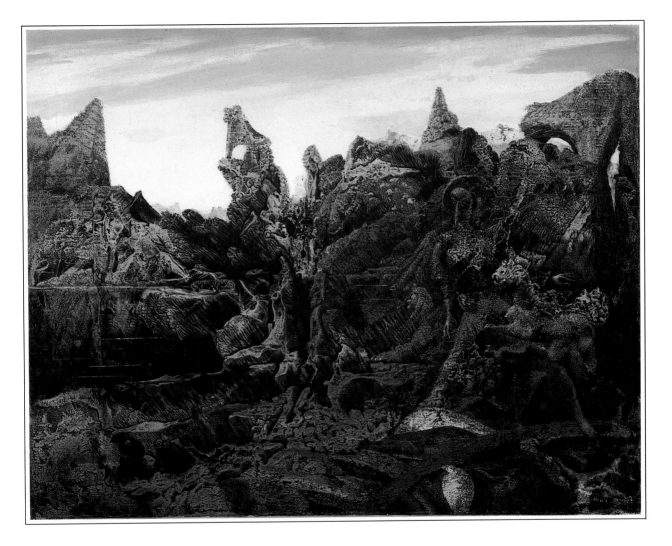

Landscape with Lake and Chimeras *c.*1940
Max Ernst
© SPADEM/ADAGP, Paris and DACS, London 1995

Grattage and paint

◁ *Previous page 29*

IN THE 1930s, a time of anxiety for German artists even if they lived in Paris, Ernst began to paint phantasmagoric and desolate landscapes peopled with shrivelling creatures. Frottages, or rubbings, of paint areas became more common on his canvases of the subconscious mind. In these there is a hint of Ernst's resorting to fragments of real rocks or pumice stones as 'models', which perhaps he gathered for study in his studio much as some artists did in Renaissance times. Ernst was now experimenting with a number of new techniques, including frottage, grattage, which meant scratching off paint surfaces and allowing what remained to suggest a new subject; and decalcomania, which involved sticking decals (transfers) on to a canvas, then scraping them or painting over them.

▷ **The Entire City** 1933
Max Ernst
© SPADEM/ADAGP, Paris and DACS, London 1995

Paint, frottage, grattage, etc.

THE YEARS LEADING UP TO the Second World War, with the threat of the three dictators of Europe looming over the political scene, had a profound effect on the art of the period. Picasso painted *Guernica* in 1936, Dalí his *Soft Construction with Boiled Beans: Premonition of Civil War* (see page 72) at the same time. Miró went through a Tragic Realism phase and Ernst produced a series of city pictures which were created by rubbing, scratching and other unusual techniques that expressed his feeling of foreboding. At first glance these works look like distant views of cities seen on the horizon, as in paintings of Renaissance towns, but a close inspection reveals a desolate landscape. In the course of time these paintings have come to be seen as a record of a tense and unhappy period in the history of Europe.

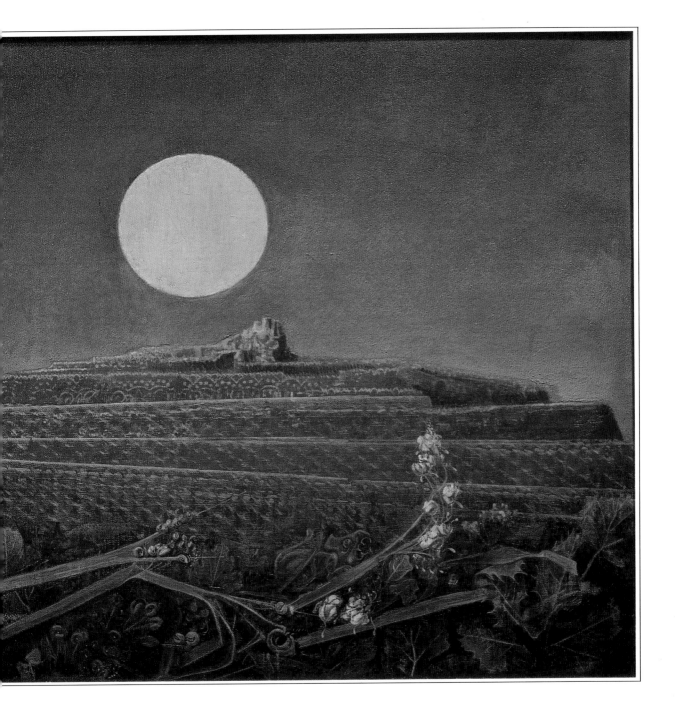

▷ **The Mask of Flora** 1931
Thomas Esmond Lowinsky (1892-1947)

Oil on canvas

THIS CRACKED AND PATCHED austere mask in its frame is set against a bleak background, staring out impassively at the spectator like the oracles at Baia. The title suggests the mythological connection and gives the clue to the hidden meaning that underlies much of Surrealism and makes it into something of an intellectual parlour game. Like much Surrealist painting, the technique here is conventional and offers little stimulus to the eye: the object of the painting is to prod the brain into a reaction. Lowinsky, who was born in Poland, studied at the Slade School in London and became a skilful draughtsman who was much in demand for book illustration.

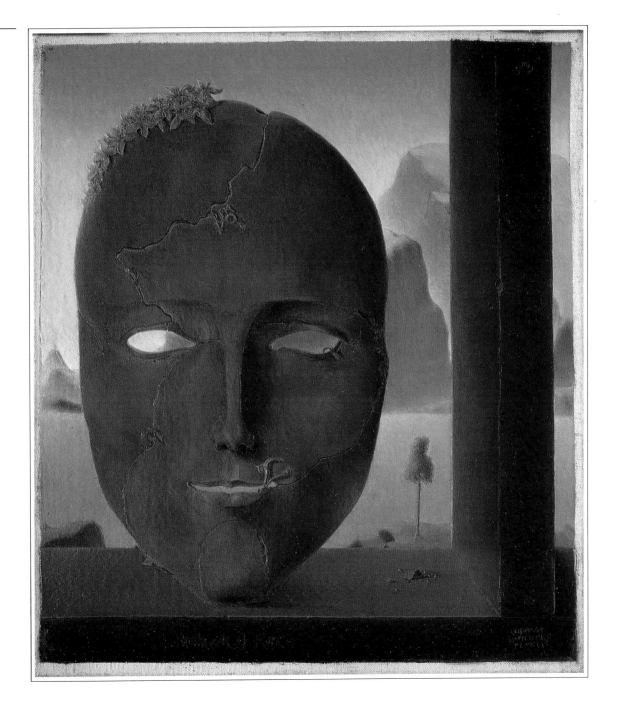

▷ **Harlequin's Carnival** 1924
Joan Miró (1893-1983)
© ADAGP, Paris and DACS, London 1995

Oil on canvas

THERE ARE MANY familiar features of Joan Miró's work in this painting. The black star in the sky outside the window, the insect-like creatures, the snakes, the two-dimensional circular heads and the calligraphic arabesques. There is not a harlequin in sight, but the whole painting has the air of a harlequinade and is so admirably composed that it possesses the essential quality of all great works of art of being a self-sufficient unit with a life of its own. At the time he was painting this cheerful work Miró was not doing well and, according to him, he began to draw hunger-induced hallucinations. His imagination, he said, had been stimulated by his poet friends of the period, who stirred up in him the feeling that his paintings should be more poetic.

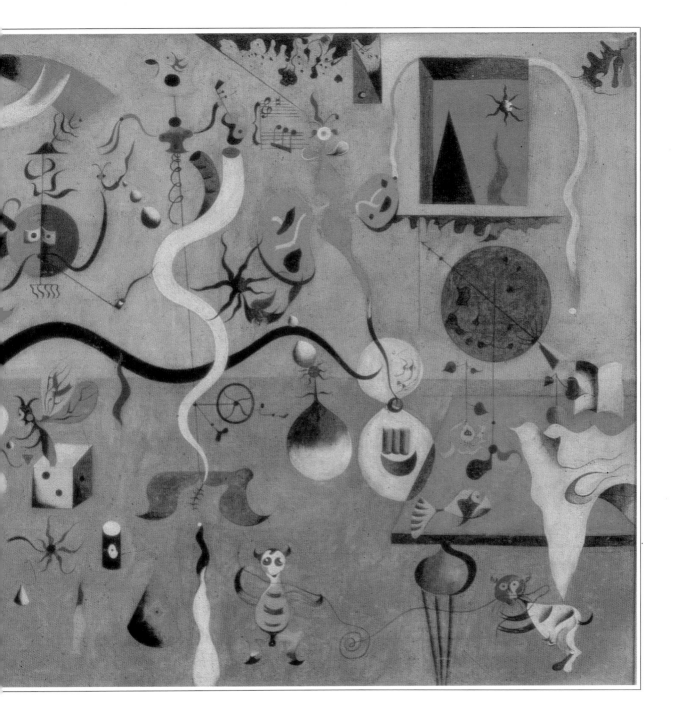

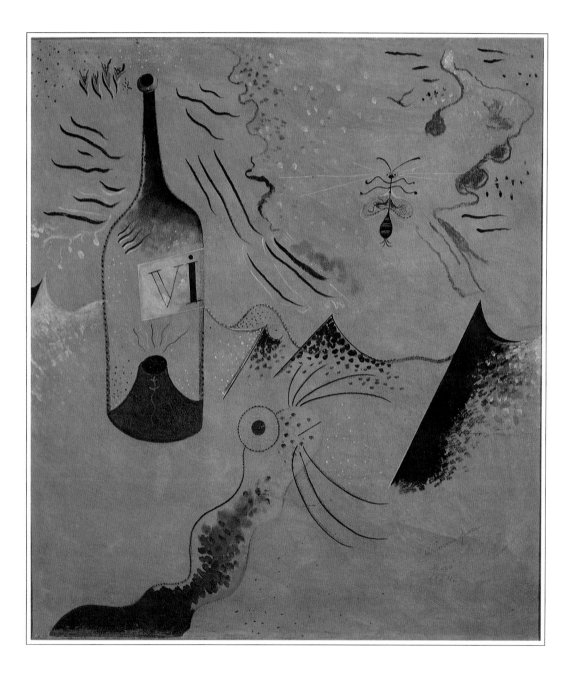

◁ **The Bottle of Wine** 1924
Joan Miró
© ADAGP, Paris and DACS, London 1995

Oil on canvas

MUCH OF JOAN MIRO'S early life was spent at the family *mas* (small estate) at Montroig near Tarragona. This gave him a strong feeling of the reality of the land and its people, which is particularly evident in his ceramics and sculptures. This delightful early work fits its title, which seems to be singing the praise of wine, a product of the Tarragona region. Already there are signs of the bubbling Miró style with its joyous calligraphy and small insect shapes. The setting out of the composition looks like the spontaneous result of the equivalent of automatic writing, which Surrealist writers adopted as a means of freeing themselves from the control of the conscious ego. Miró, who was a Catalan and friend of Picasso, took part in the first Surrealist exhibition.

Women, Bird by Moonlight c.1939 Joan Miró
© ADAGP, Paris and DACS, London 1995

Oil on canvas

▷ *Overleaf page 38*

MIRO BEGAN TO PAINT in 1912 and had his first exhibition in Barcelona, his native city, in 1918. It was not a success, nor was a second exhibition in Paris not long after. He then decided to rethink his Cubist/ Impressionist style and began to work out his own form of expression. He was drawn to Surrealism for a while and in 1926 collaborated with Ernst in designs for Diaghilev's Russian ballet. Eventually, he found his own style, in which semi-abstract shapes dance about in the canvas space. Though Miró's work bordered on abstraction, he claimed that all of his forms were derived from real things and were therefore interpretations of reality, but through the corridors of the subconscious. There is a charming childlike quality about his work that confirms his explanation and the inventiveness of a mind cleared of conventional thinking.

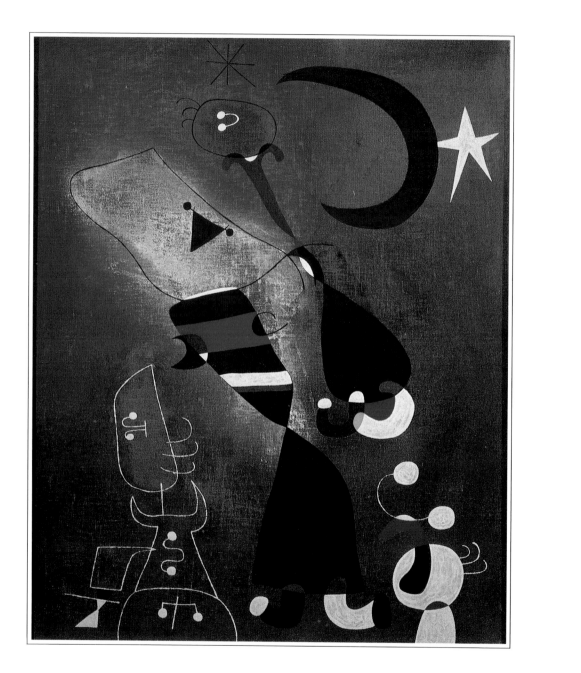

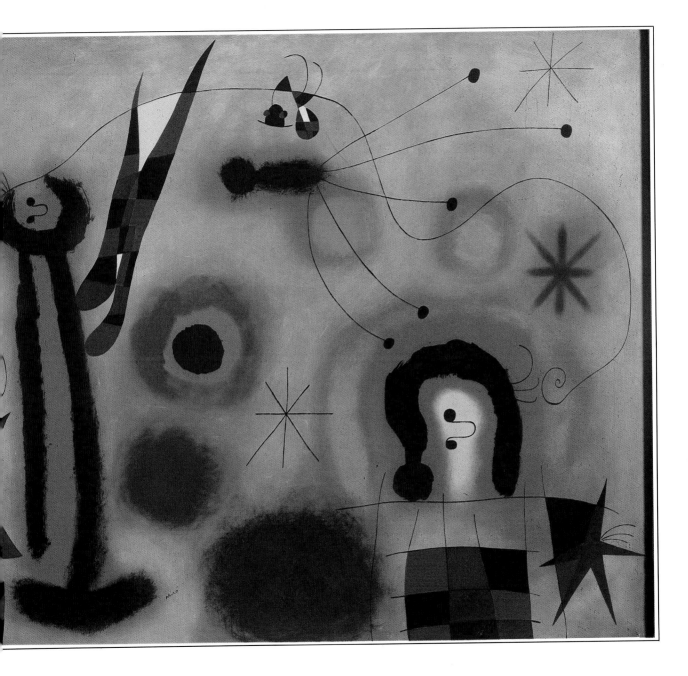

Dragonfly with red wings chasing a serpent which skips away in a spiral towards the Comet 1951
Joan Miró
© ADAGP, Paris and DACS, London 1995

Oil on canvas

◁ *Previous pages 38-39*

MIRO RETURNED to his homeland in 1940 as a successful artist: he had been commissioned to paint a six-panel mural in the Spanish Pavilion at the Paris International Exhibition in 1937. On returning, he set up home in Majorca, the island of his ancestors, and in this neutral and peaceful environment he continued to develop his painting. He also took up ceramics, a new departure that brought him a commission to decorate the UNESCO building in Paris and also a hall at Harvard University in America. His work remained unchanging once he had stabilized his style, but was full of the variety of his fertile mind. As well as painting and ceramics, Miró made three-dimensional sculptures and designed many effigies for carnivals.

▷ **Landscape from a Dream**
c.1934
Paul Nash (1889-1946)

Oil on canvas

PAUL NASH WAS A PRODUCT of the Slade School in London and was therefore trained in the strict draughtsmanship and composition of that establishment. In this painting the realistic background landscape of the Dorset coast is broken up by the screen and mirror effect, which gives a double vision quality to the top of the painting. Nash was attracted to Surrealism as a means to escape from the established styles of painting and exhibited with the Surrealists in Paris in 1938. He was a war artist during both World Wars and made several memorable paintings of the trenches and air battles over Britain, many of which can be seen at the Imperial War Museum in London.

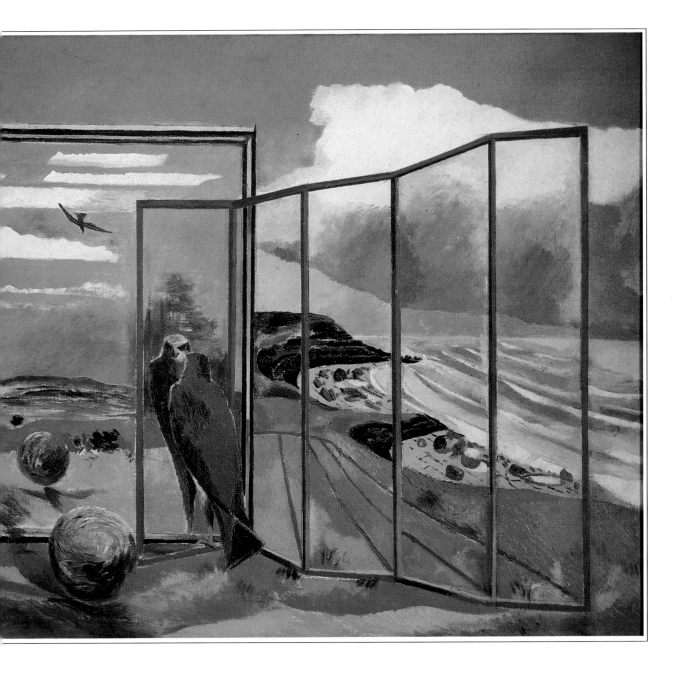

▷ **Belles de Nuit** 1936
Paul Delvaux (1897-1994)
© Fondation P Delvaux – St Idesbald, Belgium/DACS 1995

Oil on canvas

THE LADIES OF THE NIGHT in this painting have a Pompeian look about them, as does the house behind them. The treeless landscape with its shattered mountains beyond could be another version of a dormant Vesuvius, or is this what was left after the catastrophe? The air of desolation and separation of Delvaux's paintings is here accentuated by the naive realism of his painting style. Delvaux's interest in classical architecture took him to Italy in 1939, where he was able to see for himself the ruins of its ancient civilization. His painting style was influenced by his admiration for the work of the Quattrocento artists, Piero della Francesca, Andrea Mantegna and, above all, Paolo Uccello.

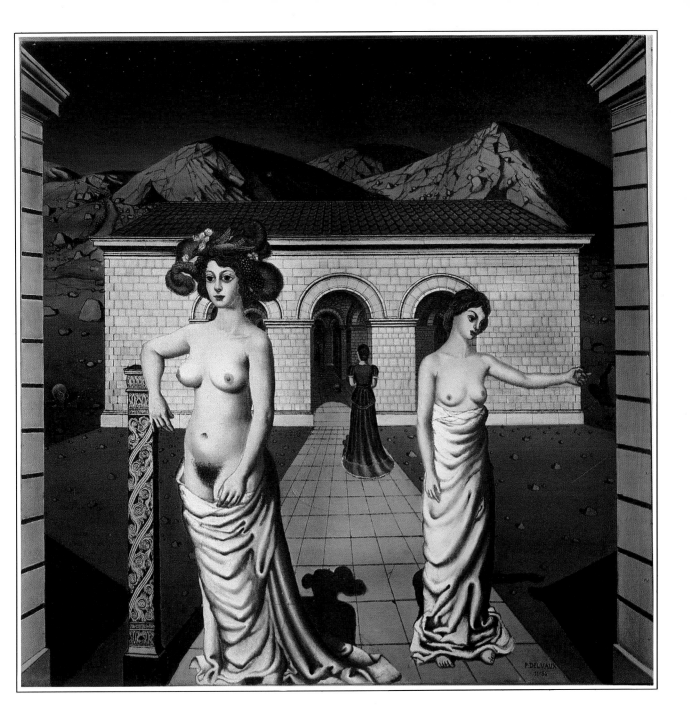

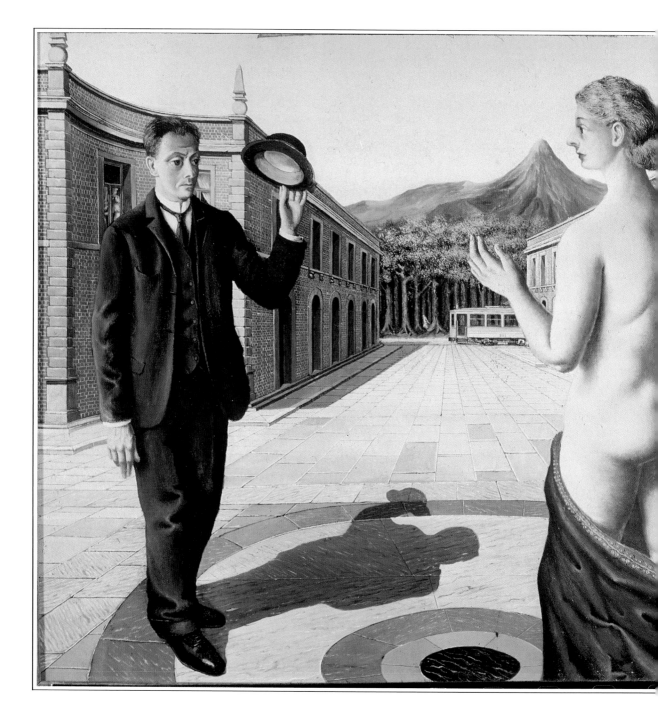

◁ **The Greeting** 1938
Paul Delvaux
© Fondation P Delvaux – St
Idesbald, Belgium/DACS 1995

Oil on canvas

THE SUBCONSCIOUS REACHES of
the mind surface in Surrealist
paintings, sometimes as
abstract or semi-abstract
visions and at other times as a
dream-like reality. Delvaux was
a master of the latter, a more
accessible image. A Belgian
who trained in Brussels, he has
something of Hieronymous
Bosch in his urban landscapes
peopled by somnambulists
who appear to be living out
their dream lives with the
same anxiety as the medieval
people of Bosch's world.
Delvaux characters, however,
live in empty towns of classical
buildings, a reference to the
Greco-Roman culture of
Western civilization. In this
painting, the juxtaposition of a
conventional businessman with
the nude woman provides a
sexual image disturbed by the
tram and volcano seen in the
distance.

▷ **The Call of the Night** 1938
Paul Delvaux
© Fondation P Delvaux – St Idesbald, Belgium/DACS 1995

Oil on canvas

HERE DELVAUX HAS DESERTED his classical urban setting and resorted to a view of nature in which ruined Stone Age monuments stand in a landscape lit by bare candlelit trees. The skeleton that appears in other Delvaux paintings is now simply a collection of bones scattered about the landscape, pale and desiccated in contrast to the rich vegetation growing out of the women's heads. The spirit lamp that one woman passes to another one veiled in a white sheet seems a symbol of life. In all Delvaux's work there is an uneasy atmosphere full of forebodings, but not necessarily of menace, and the women play the role of nudes in Renaissance art – decorative vessels for an idea to which there is no easy answer.

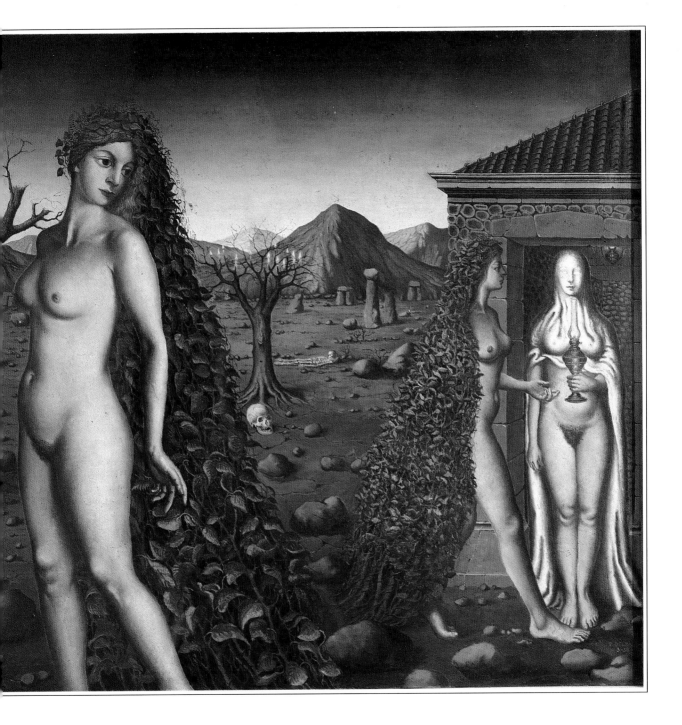

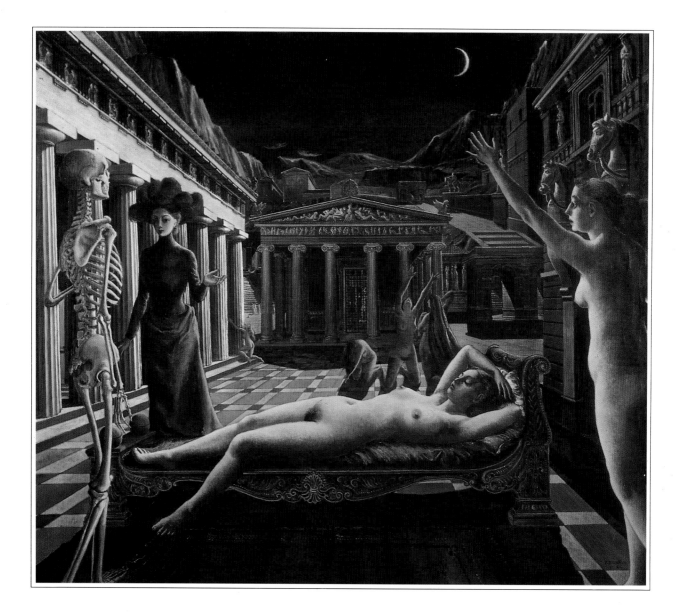

◁ **Venus Asleep** 1944
Paul Delvaux
© Fondation P Delvaux – St Idesbald, Belgium/DACS 1995

Oil on canvas

THE ROMAN STAGE of Delvaux's subconscious mind is the setting for this painting, whose meaning is more accessible than that much of his work. The skeleton greeting the fully dressed lady in her Edwardian attire is the clue to the dramatic scene, in which a nude woman is laid out on what passes for a sacrificial altar. The nude's passivity also suggests something other than a sexual meaning. Her companions in the background are flinging themselves about in attitudes of despair but the dream-like quality of the whole scene deprives it of the stress that realism would inspire. The new moon is, perhaps, a symbol of hope, although it could also be the dying moon in its final quarter.

The Red City (La Ville Rouge) 1943/4 Paul Delvaux
© Fondation P Delvaux – St Idesbald, Belgium/DACS 1995

Oil on canvas

▷ *Overleaf pages 50-51*

THE CLARITY OF DELVAUX'S PAINTING and his linear technique are reminiscent of Botticelli. Like the Renaissance artist, Delvaux is less interested in exploring new theories and techniques than in telling his story by using a conventional and easily accessible manner and using characters with whom both he and his audience are familiar. In this painting, the skeleton serves the same kind of purpose as in *Venus Asleep*: it is a presence without a specific role. This time the androgynous person whom he approaches seems to have a similarity to the dark-haired woman on the left of the picture, whose left hand repeats the gesture of the young man/woman's left hand. The meaning is unclear but there is a feeling of action and answered questions, much as in Botticelli's *Primavera*.

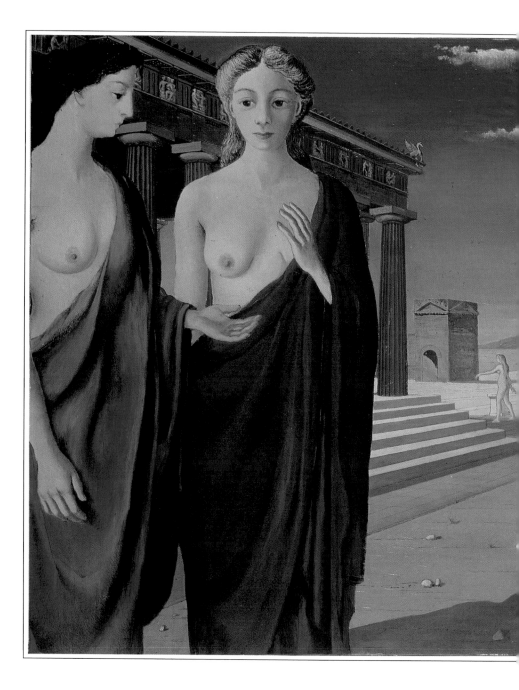

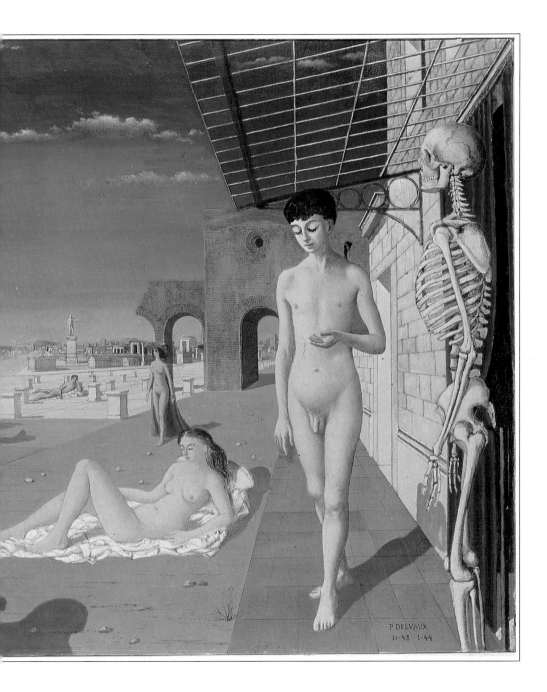

▷ **The Signs of Evening** 1926
René Magritte (1898-1967)
© ADAGP, Paris and DACS, London 1995

Oil on canvas

THE AMBIGUITIES of a painting by René Magritte come from his deeply introspective nature and are the response of a thoughtful observer to the surface life about him. In this painting the signs of evening do not seem to refer to any particular day or meteorological condition. The double vision effect of the frame takes the scene into a timeless world in which the scene within the frame and the one outside are all one, as suggested by the round ball or fruit that has rolled away from the inner picture into the foreground, which is reminiscent of the empty piazzas of Chirico's lonely cities. The dark mountains in the background add a sombre note to an otherwise charming scene.

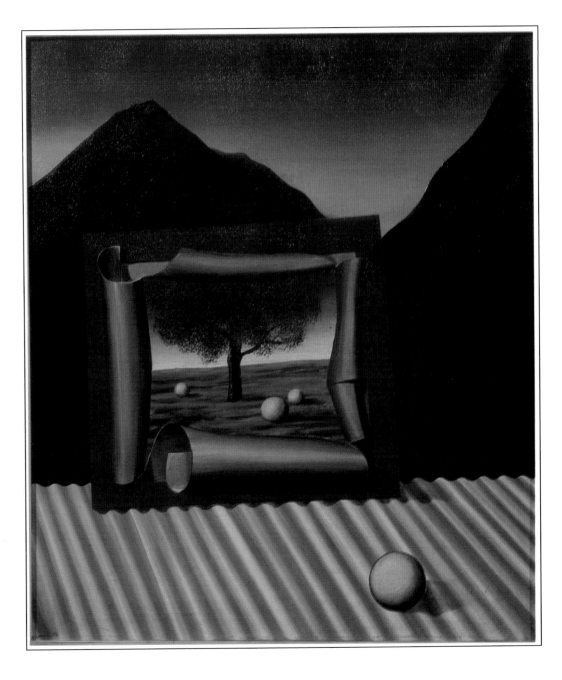

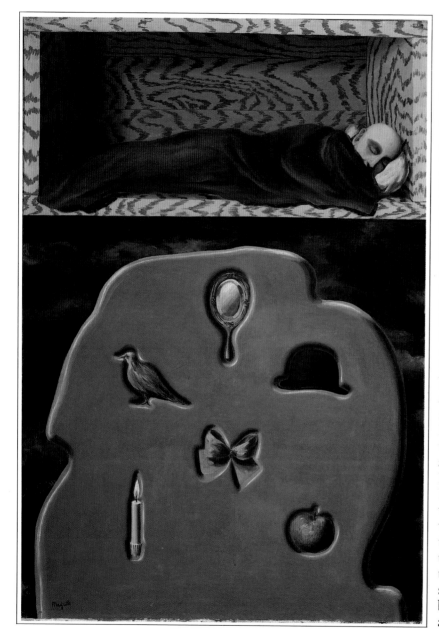

Oil on canvas

THE FRENCH TITLE of this work describes the man as *téméraire*, which suggests daring rather than reckless. Nothing seems less reckless than the man wrapped in his blanket on the shelf above the objects, which perhaps exist only in his subconscious. The objects are extremely mundane, suggesting either that the daring man is so only in his imagination or that the objects are not what they seem. At about this time in his career Magritte went through a phase being obsessed with the idea of ambiguity. On a painting of a smoker's pipe done at this time he wrote *'Ceci n'est une pipe'*. At the time of that break-out from all the conventions of Greco-Roman-Renaissance culture, Magritte was working in a wallpaper factory. By 1926 he was devoting himself full time to creating the images that were to make him famous. Most of them, like the objects below the sleeping man, were inspired by bric-à-brac he might have found around his house.

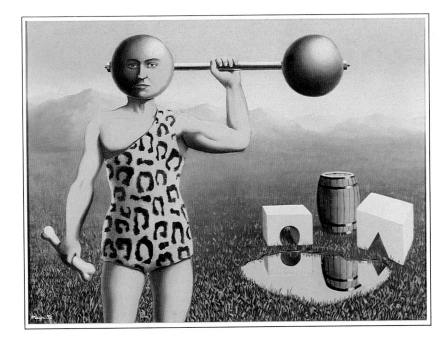

△ **Perpetual Motion** 1934 René Magritte
© ADAGP, Paris and DACS, London 1995

Oil on canvas

BETWEEN 1927 and 1930 René Magritte had become established as a Surrealist with a surprising imagination, which was able to create new visions out of a domestic landscape. In fact, he preferred the domestic scene to such an extent that he painted in his kitchen rather than in a studio. As a Surrealist, he contributed to *La Revolution Surrealiste,* a journal that promoted the Surrealist message. By the time this picture was painted Magritte had established his style; he claimed would shock visitors by obliging them to re-think their thoughts by the unexpected juxtaposition of the objects. In this picture the weight held by the man, which is also the man's head, and the cubes reflected in the mirror or pool of water seem to suggest man's potential for thought or absence thereof.

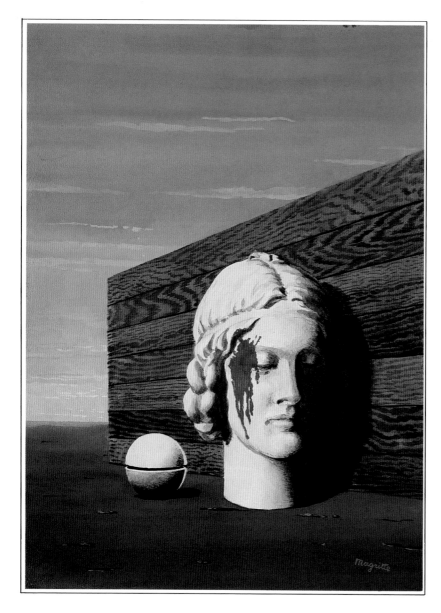

◁ **La Memoire** 1948
René Magritte
© ADAGP, Paris and DACS,
London 1995

Oil on canvas

THE PLASTER CAST of a
woman's head does not arouse
feelings of horror or
repugnance, for this painting
as a whole has a dreamlike
quality that is reassuring. As in
most dreams, the spectator
knows that it will pass and
everything will be restored to
normal. Memory played an
important part in Magritte's
work for he believed in staying
close, in his paintings, to the
original objects that had
inspired him. Few of
Magritte's paintings are
menacing; they suggest that
the message behind them is
food for thought rather than
an inspirer of fear. The solitary
leaf in this picture strikes a
note of hope and comfort.

▷ **The Natural Graces** 1962
René Magritte
© ADAGP, Paris and DACS,
London 1995

Oil on canvas

THIS STRAIGHTFORWARD and
sentimental work showing
foliage growing into doves
expresses the unity of nature.
It has a monumental character,
heightened by the small scale
of the distant landscape.
The gentleness of the creatures
is contrasted with the arid
mountains on the horizon,
which give the painting
something of the feeling of a
Renaissance Madonna with a
landscape such as Bellini
might have painted. The
feeling of peace and tranquillity
reflects the painter's own spirit
which, despite the sometimes
disturbing images of his
subconscious, seems to have
thrived on the quiet domesticity
of his home life. Magritte
painted several versions of this
picture. The first was for a wall
decoration in the Knocke-le-
Zoute Casino, unveiled before
a gathering that included
Maurice Chevalier and Yves
Montand but not the artist – he
had been refused entry because
of a quarrel with the proprietor
over money.

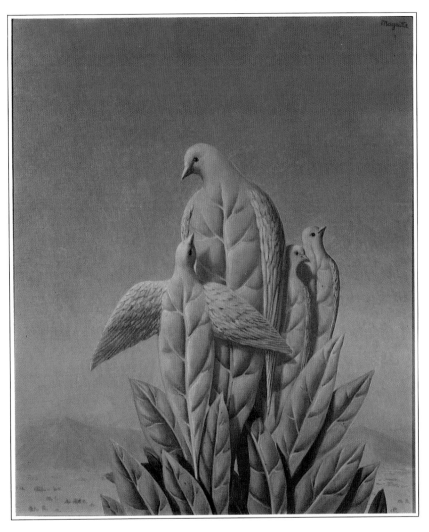

▷ **The Road to Damascus** 1966
René Magritte
© ADAGP, Paris and DACS, London 1995

Oil on canvas

HERE, AS IN *Perpetual Motion*, Magritte seems to be thinking of man as a creature with a brain that is an empty space at birth. But this space is the means for acquiring information and thinking about the outside world. The bowler hat and the modest clerk's suit as well as the man himself are very ordinary, but the circumstances of their existence are not. Magritte's sardonic style avoids making a comment but he seems to be asking a question, which the viewer or the man in the picture must make up for himself as well as finding its answer.

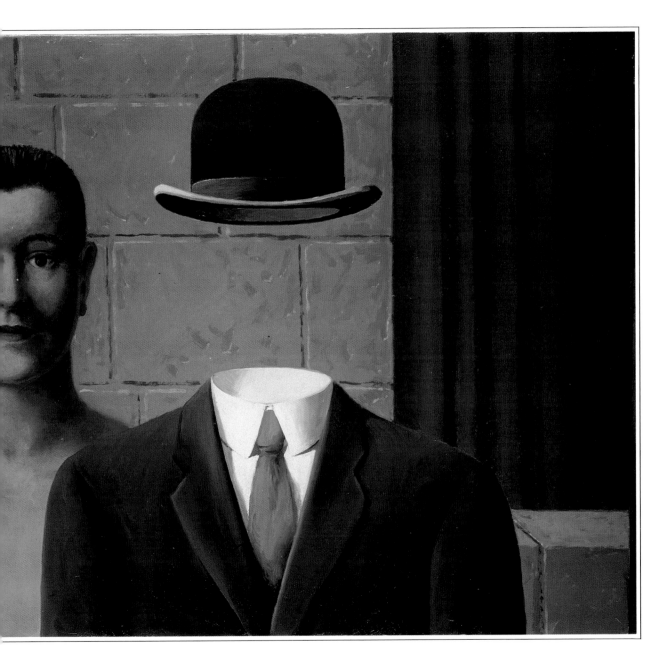

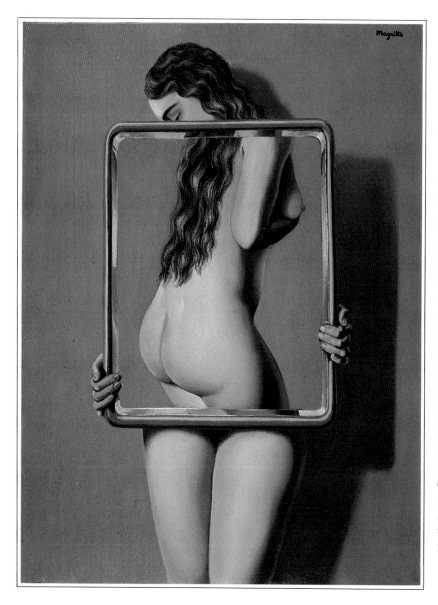

◁ **The Dangerous Liaison**
René Magritte
© ADAGP, Paris and DACS,
London 1995

Oil on canvas

THE INVENTIVE MIND of René
Magritte created a
subconscious wonderland of
domesticity: bowler hats,
mirrors, cupboards, clothes
hangers, musical instruments
were transformed by his poetic
fantasy into objects that were
both familiar and strange.
Although first attracted by
Impressionism, Magritte soon
realized that this open-air
painting technique was quite
inappropriate for the
exploration of the twilight
zone of the mind, an
exploration which might
produce images of tubas in the
sky, railway engines emerging
from fireplaces and a female
torso masquerading as a face.
In this painting, that, like a
conjuror's trick, is done with
mirrors, there is a hint of the
kind of mysterious sexual
world sometimes uncovered by
mass observation surveys.

▷ **Dehors** 1929
Yves Tanguy (1900-1955)
© DACS 1995

Oil on canvas

IN THIS UNUSUAL PICTURE,
painted at the time that
Tanguy, who had been a
seaman, decided that his true
vocation was to be a painter,
there is an impressive feeling
of empty space, in which the
most important element is a
splodge of ill-defined colour
dissolving into emptiness. In
the upper edge of the painting
the feeling of infinite depth
increases, making the
foreground seem a small and
unimportant element of the
whole. The spaciousness
reminds one of Perugino's
infinite skies.But saints and
madonnas have no place here:
instead, there are nameless
and unrecognizable creatures
from a different space and
time .

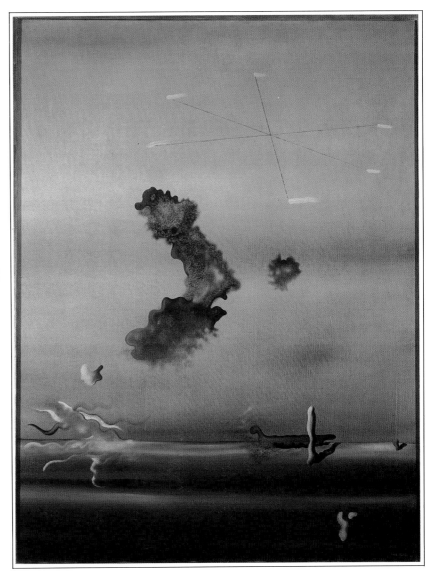

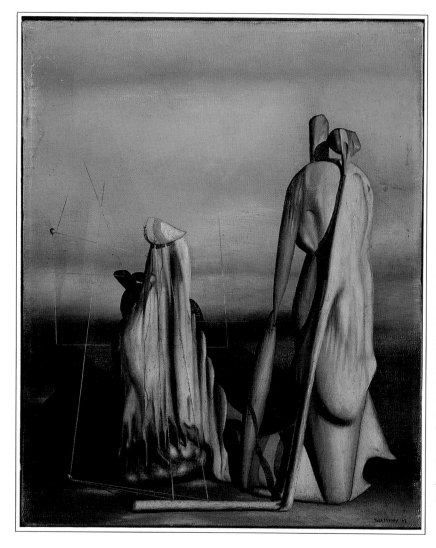

◁ **Untitled** 1940
Yves Tanguy
© DACS 1995

Oil on canvas

TANGUY'S MONUMENTAL figures
are reminiscent of Dolomitic
peaks, while the background
gives a feeling of a vast
receding space. The feeling
that this space is a kind of
reality is heightened by the
shadows cast by the cold light
coming in from the side.
Though Tanguy tries to avoid
identifying his forms, he does
not entirely succeed, for here
and there are hints of human
anatomy and geological
formations. This is inevitable,
for all shapes are in nature
and it is what gives Tanguy's
work a sense of reincarnation
from real life in a new
continuum of space and time.
Though untitled here, the
painting has appeared under
the name of *Les Prodigues (The
Prodigals)*, though this does
little to explain its meaning.

▷ **The Saltimbanques** 1954
Yves Tanguy
© DACS 1995

Oil on canvas

WHETHER TANGUY MEANT the
Saltimbanques as
mountebanks, showmen or
buffoons is not clear, but the
painting suggests something of
all three. The composition
looks like a procession
approaching from a distance,
with the leading figures as
anthropomorphic forms
assembled in an arbitrary
manner. The red rectangle is
the only strong patch of colour
in what is almost a
monochrome picture. Tanguy
is evidently more concerned
with the relationships of small
forms than with colour
theories, but he has produced
a well-balanced picture with
everything in its place,
creating a sense of both
movement and repose.

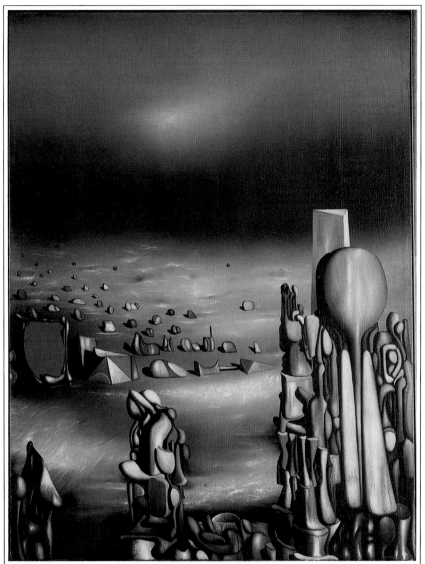

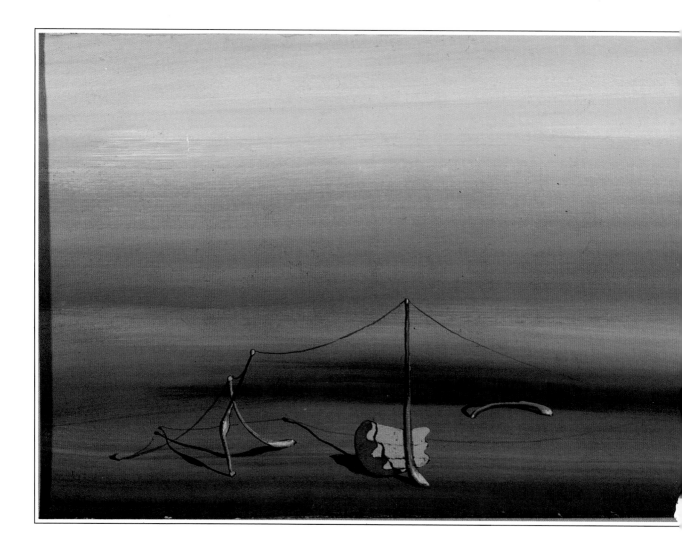

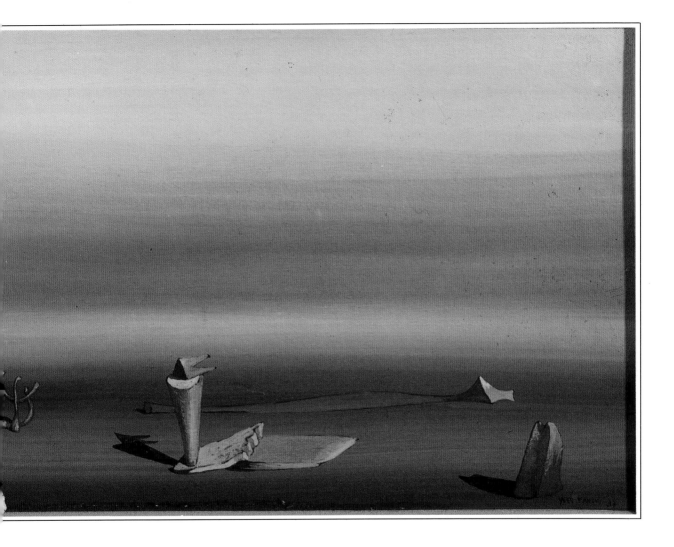

▷ **Still Life** 1950
Alberto Giacometti 1901-66
© ADAGP, Paris and DACS,
London 1995

Oil on canvas

FROM THE École des Arts et
Métiers in Geneva, Alberto
Giacometti went to Italy in
1920 to study classical and
Renaissance art. It does not
seem to have made such an
impression on him as his time
at the Academie of the Grande
Chaumière in Paris, where his
drawings began to assume the
idiosyncratic character that was
to set his sculpture apart from
the work of his
contemporaries. His friendship
with fellow artiat André
Masson reassured him that his
particular vision was true and
he continued to develop his
thin figures. These were drawn
with enormous care and
Giacometti spent days refining
the emaciated forms of his
work. According to him,
people look real only at a
distance; the closer they get,
the more unreal they become
until they vanish altogether. He
claimed that this was his true
vision and not an aesthetic
distortion, though the 'vision'
of which he spoke was perhaps
meant in a philosophical sense.

Poetic Landscape
Yves Tanguy
© DACS 1995

Oil on canvas

◁ *Previous pages 64-65*

YVES TANGUY WAS INSPIRED to
become a painter after seeing
exhibitions of Chirico's work.
He painted his first Surrealist
picture in 1925 after meeting
André Breton, one of the
founders of the Surrealist
movement. Perhaps his
previous life as a seaman,
exposed to broad horizons of
sea and sky had conditioned in
him a feeling for space, which
he populated with amorphous
creatures. There is no trace in
his paintings of the classical
echoes found in Chirico nor,
indeed, any other influence
of subject or technique.
He is truly original, having
created his own world, which
is real not only to himself
but to the viewer.

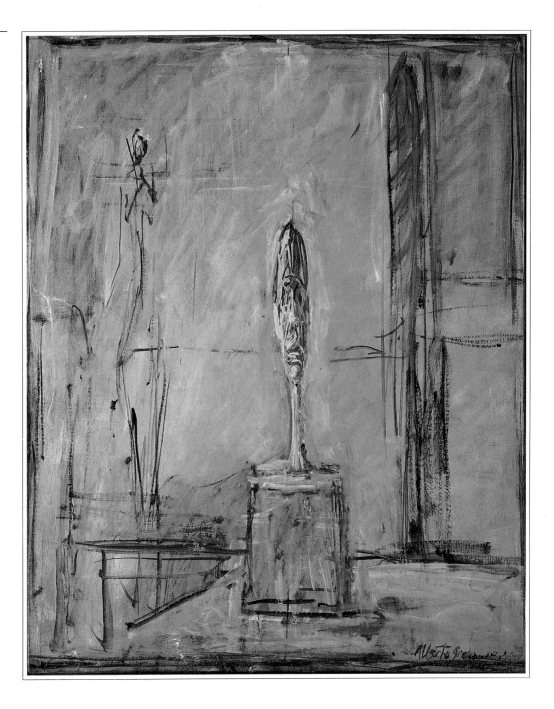

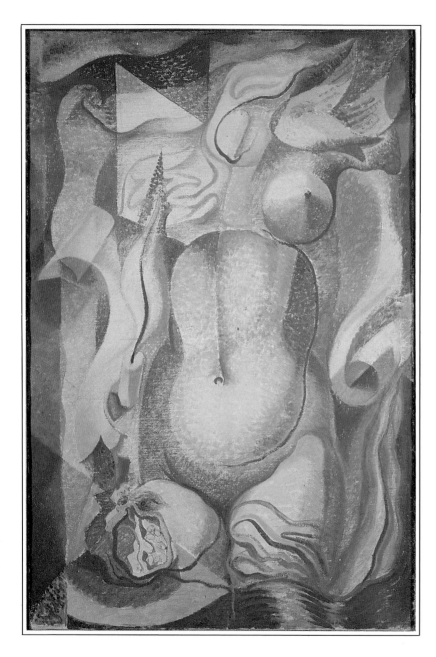

◁ **Armour** 1920s
André Masson (1896-1987)
© ADAGP, Paris and DACS,
London 1995

Gouache

ANDRÉ MASSON STUDIED mural
painting at the École Nationale
des Beaux Arts in Paris from
the age of 16, but found an
academic approach to painting
unsatisfactory for his
expressive needs. In 1924 he
met André Breton, who
persuaded him to join the
Surrealist Movement. The
move liberated Masson, giving
him the confidence to launch
himself into automatic writing
and drawing. Delving even
more deeply into art by
spontaneous gestures, by the
late 1920s he was
experimenting with throwing
sand on to canvases covered
with glue. He illustrated the
Surrealist review *Acephale* for a
while but later left Surrealism
for theatrical design. He then
went to Spain in order, he said,
to free himself of an inner
violence that he was expressing
in paintings of massacres.
The Civil War broke out while
he was in Spain and for a
while he worked for the
Republican cause before
returning to France.

▷ **Portrait of Valentine** 1937
Roland Penrose (1900-1984)

Oil on canvas

THE FIRST SURREALIST
exhibition in Britain was
organized by Roland Penrose,
a Surrealist painter and
collector who became
interested in the new
movement in painting when it
was launched in France by
André Breton following the
demise of Dada. At this time in
Britain, modern art was
looked upon with some
suspicion and Penrose's
initiative caused a flurry. The
exhibition was held in London
at the New Burlington
Galleries in 1936 and was
attended by, among others,
Salvador Dalí, who arrived to
lecture in a diving suit – and
had some difficulty in speaking
through the helmet. Penrose
continued to be the leading
British Surrealist with a special
interest in collage, as can be
seen in this painting of a head
with butterflies and birds. Like
many Surrealists, Penrose
found it difficult to separate
the literary from the plastic
meanings of his work.

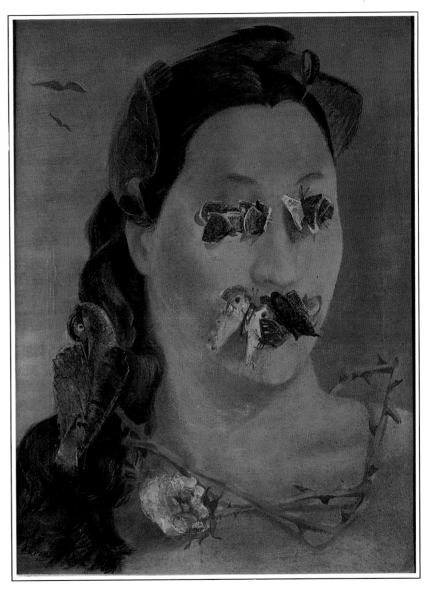

▷ **The Disintegration of the Persistence of Memory** *c.*1934
Salvador Dalí 1904-1987
© DEMART PRO ARTE BV/DACS 1995

Oil on canvas

SALVADOR DALÍ'S flair for taking prevailing ideas and re-presenting them in a novel and Surrealist manner struck a chord in the public consciousness. His accessibility was achieved by painting in an Old Master manner that was admired for its skill even when his subjects were not understood. In the 1930s ideas about the significance of time, which had arisen out of Albert Einstein's theories, were a common theme in literature, drama and journalism. Dalí had first tackled them in 1931 with a painting called *The Persistence of Memory*. The painting here echoes the theme and contents of that earlier work, but the vision has changed and the atmosphere is less serene, more charged with the theme of disintegration, though Dalí is still expressing the idea of timeless time with his famous melting watch image. The background evokes the Costa Brava, his home region, to which he retired later in life, emerging only to give one of his celebrated showman appearances.

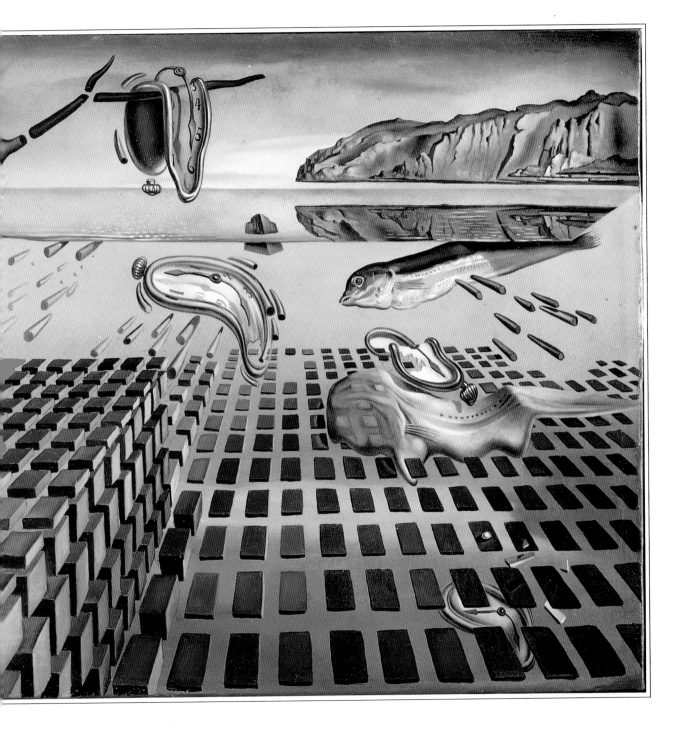

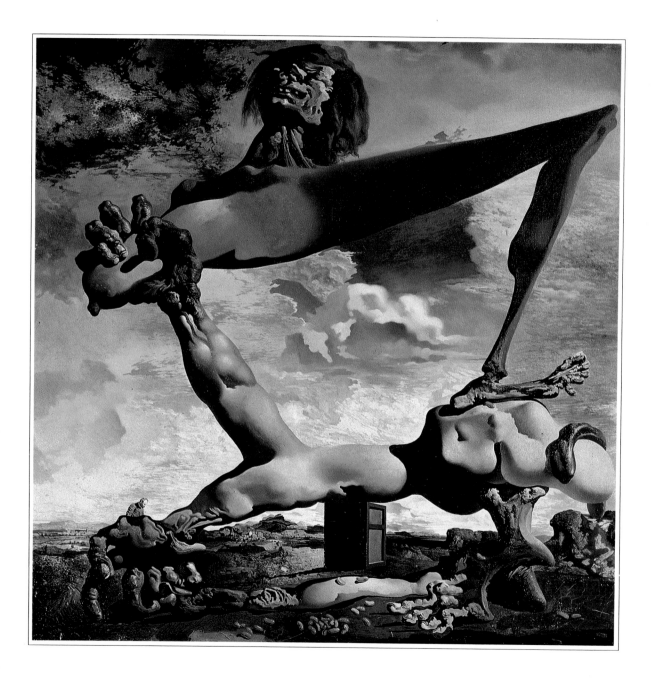

◁ **Soft Construction with Boiled Beans: Premonition of the Civil War** 1936
Salvador Dalí (1904-87)
© DEMART PRO ARTE BV/DACS 1995

Oil on canvas

IN ITS WAY, and despite the fact that it is without direct allusions to the horrors of war, this painting is as disturbing as Picasso's *Guernica*, though its suave technique glosses over the horror just as the technique of Rennaissance painters did with scenes of rape, and torture. Most Spaniards had deep forebodings about a struggle in which fellow nationals would be fighting each other. Catalonia-born Dalí has expressed this in a painting in which the obscene and the grotesque are contrasted with the simple and realistically painted man behind the gnarled hand in the left foreground with and the beans, which symbolize the daily bread of the average Spaniard of the time.

The Night and Day of the Body 1936
Salvador Dalí
© DEMART PRO ARTE BV/DACS 1995

Oil on canvas

▷ *Overleaf pages 74-75*

PAINTED IN THE YEAR that civil war broke out in Spain, this painting shows a boilersuit-style overall with flaps that are open in the daylight picture to reveal a headless woman's body whose torso is grey and stone-like while the rest of the body is flesh-coloured. The sky behind the figure is cracked and in the small, bean-shaped form in the left foreground a man is showing a boy what could be the constellation of the Great Bear. The images suggest anxiety but also hope. Since this was the year when Dalí painted the shocking *Soft Construction with Boiled Beans*, it is likely that the catastrophic developments in Spain were very much in his mind as he painted *Night and Day*.

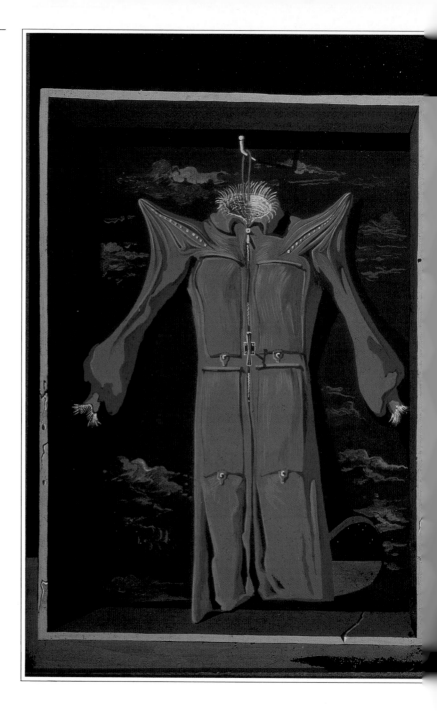

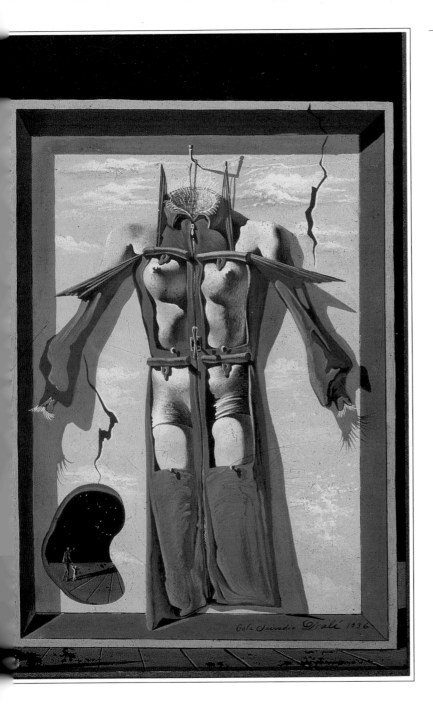

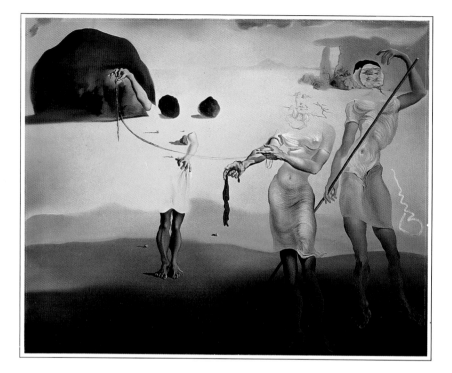

△ **Enchanted Beach with Three Fluid Graces** 1938
Salvador Dalí
© DEMART PRO ARTE BV/DACS 1995

Oil on canvas

BY THE TIME THE Spanish Civil War erupted Dalí was already a well-known figure in the capitals of Europe and America, where he moved in 1939 to Del Monte, near Hollywood. This painting shows Dalí in a relaxed and playful mood and has something of the feeling of a Botticelli with its delicate lines and elongated anatomy of the women. The *trompe l'oeil* effect in the women's heads – as a stone, a Quixotic horseman and a landscape – is an example of the Dalí whimsy, which was to appear more and more in his paintings, drawings for fashionable magazines and jewellery. In 1949 Dalí began a new phase, in which religious imagery was given the Surrealist treatment.

▷ **Composition** c.1933-4
Edward Burra (1905-1976)

Watercolour

LONDON-BORN EDWARD BURRA
was one of the most original
British painters of his period,
giving the urban scene a new
dimension appropriate to the
life of the 20th century after
the First World War. A rather
reserved and private person
who suffered much ill health,
Burra chose to live in
Brighton, away from the
artistic milieu of London,
though he also travelled
widely in Europe and the
United States. In this
Surrealist painting he has
mixed realistic images, as in
the landscape background,
with imaginary forms. His
main work was scenes in
streets and bars, which,
although not specifically
Surrealist, have the character
of this form of art by hovering
between a dream state and
reality.

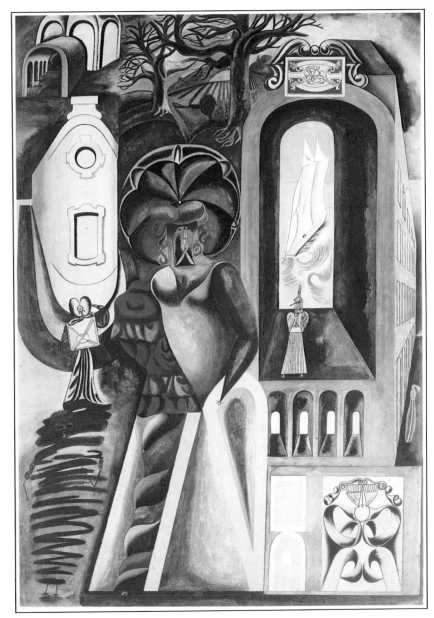

ACKNOWLEDGEMENTS

The Publisher would like to thank the following for their kind permission to reproduce the paintings in this book:

Bridgeman Art Library, London /Kunstmuseum, Hanover: 8; **/Christie's, London:** 9, 19, 36, 50-51, 78; **/Kunstmuseum, Basle:** 10; **/Private Collection:** Cover, Half-title, 11-15, 23, 28-29, 46-47, 53, 55-65, 67-71; **/Private Collection/Giraudon:** 16 **/Philadelphia Museum of Art, Pennsylvania, USA:** 18, 54, 72; **/National Gallery of Art, Washington DC:** 20; **/Tate Gallery, London:** 21-22, 26-27, 38, 48, 54; **/Towner Art Gallery, Eastbourne:** 24-25; **/Kunsthaus, Zurich:** 30-1; **/Wolverhampton Art Gallery, Staffs.:** 33; **/Albright-Knox Art Gallery, Buffalo, New York:** 34-35; **/Prado, Madrid:** 39; **/Tate Gallery, London/Reproduced by Permission of the Paul Nash Trust:** 40-41; **/Ex-Edward James Foundation, Sussex:** 43; **/Museum of Modern Art, New York:** 44-45; **/Brussels Fine Art Exhibition:** 74-75; **/Dali Museum, Beachwood, Ohio:** 76; **/Victoria & Albert Museum, London:** 77;